Bipolar Sketches

Primož Krašna

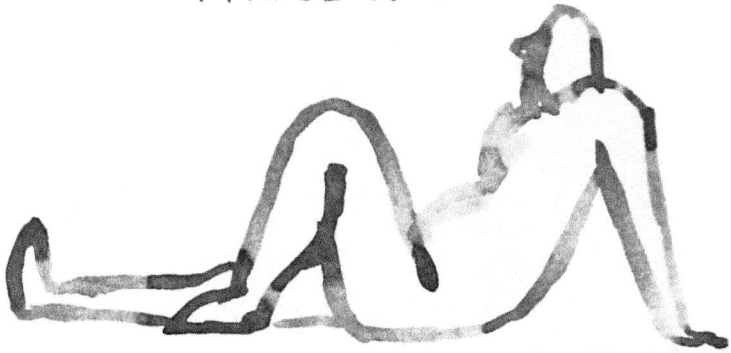

BIPOLAR SKETCHES
Primož Krašna

All works are copyrighted and can not be published without the agreement of the author.

ISBN 978-1-329-19907-1

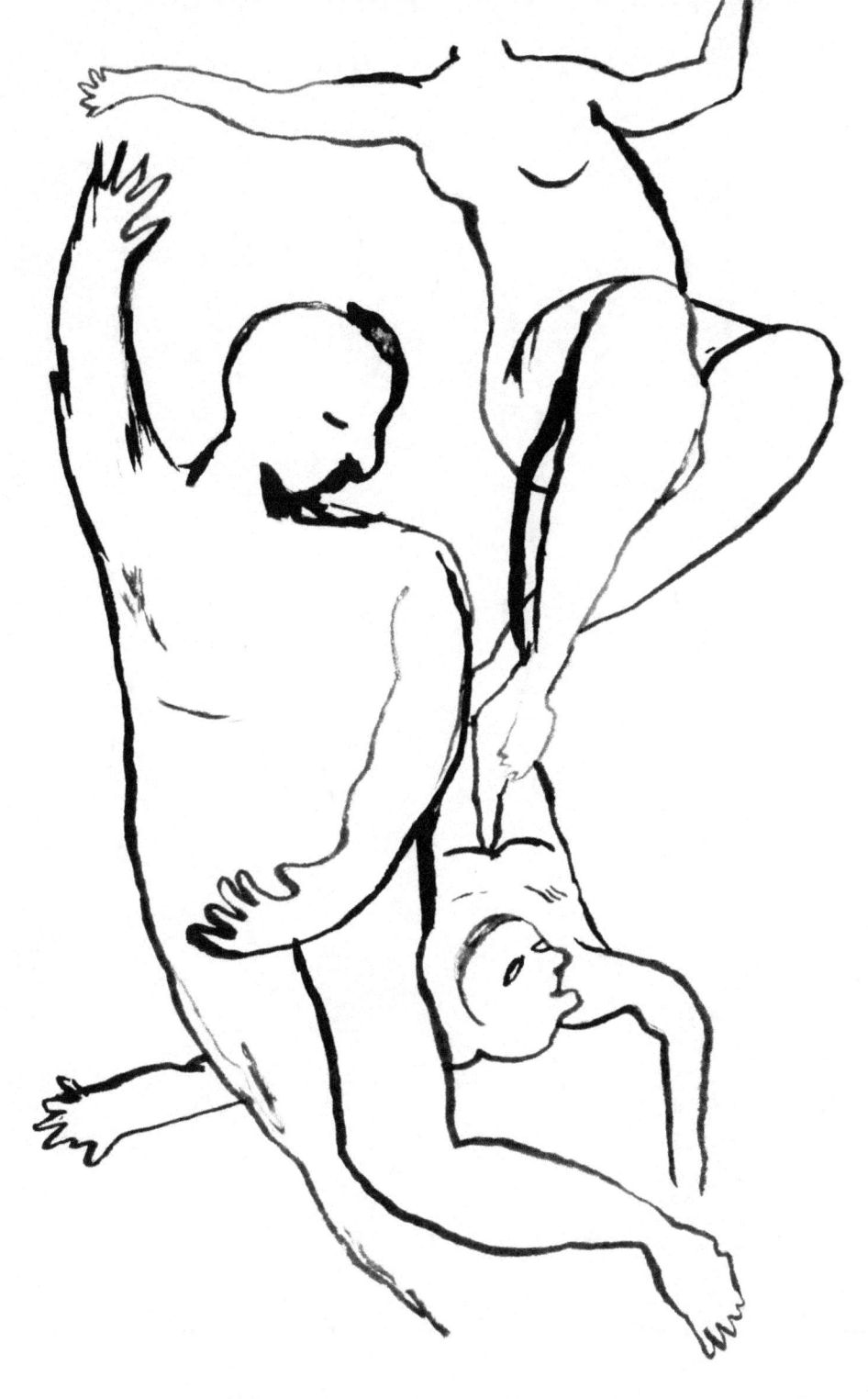

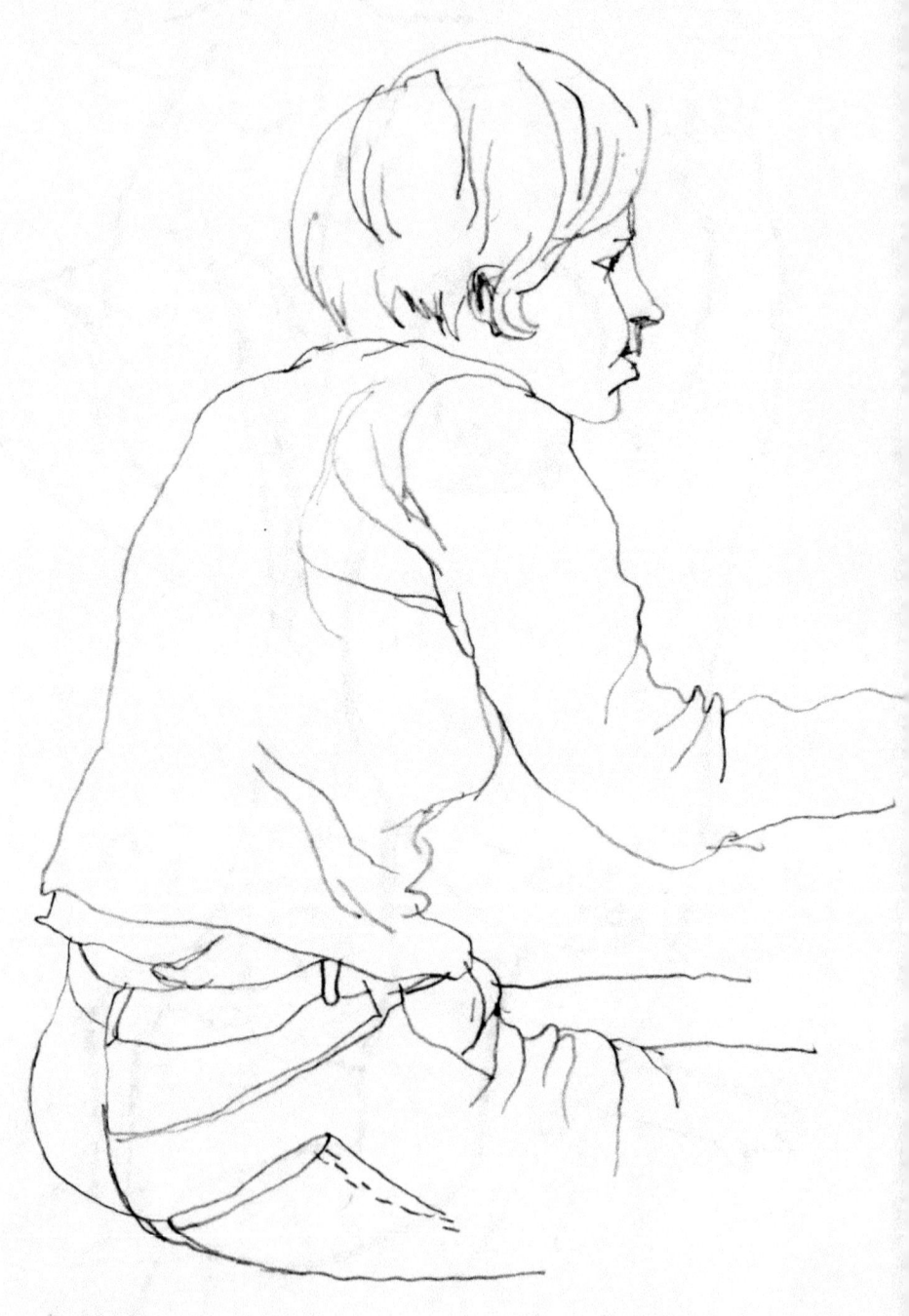

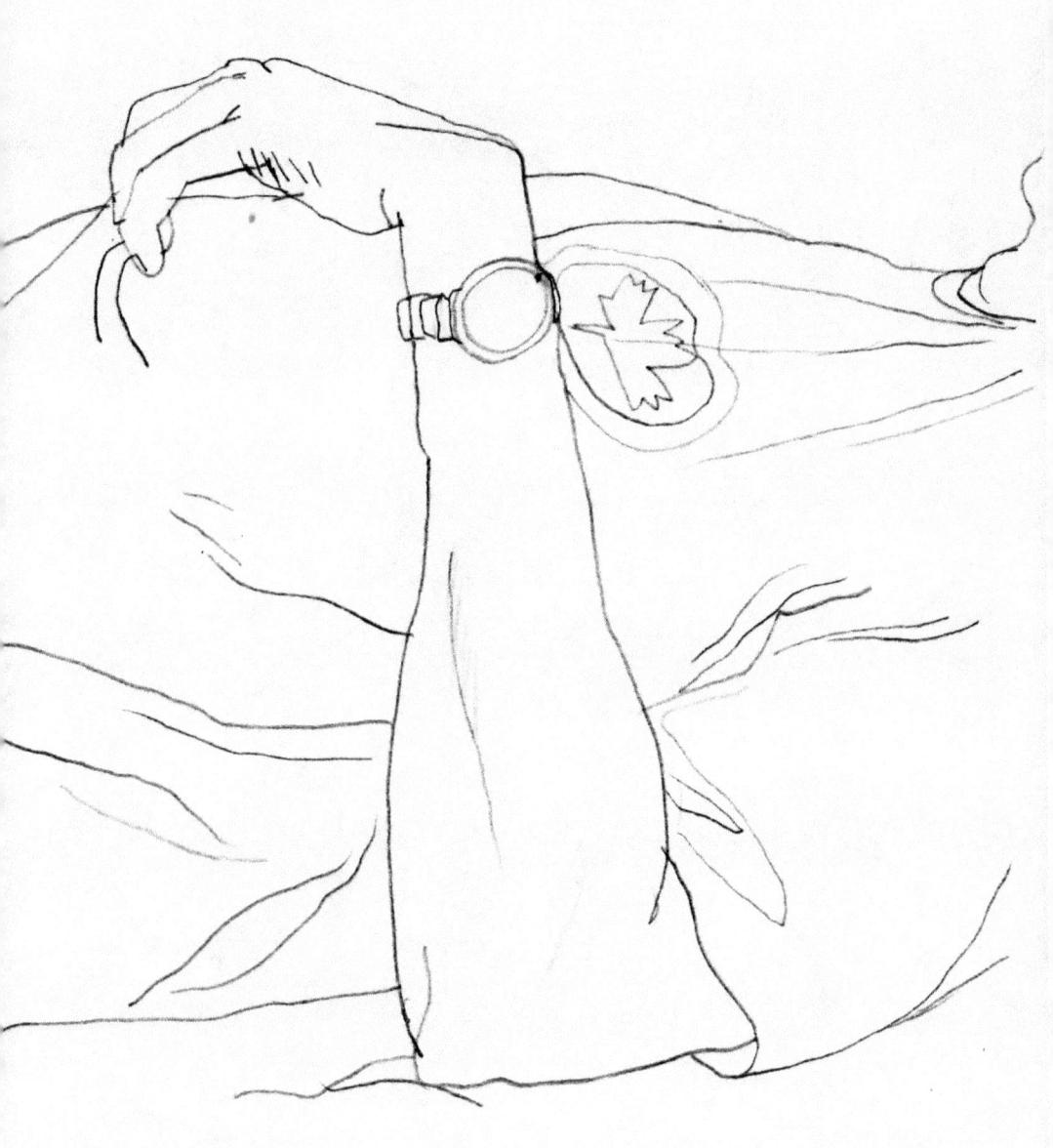

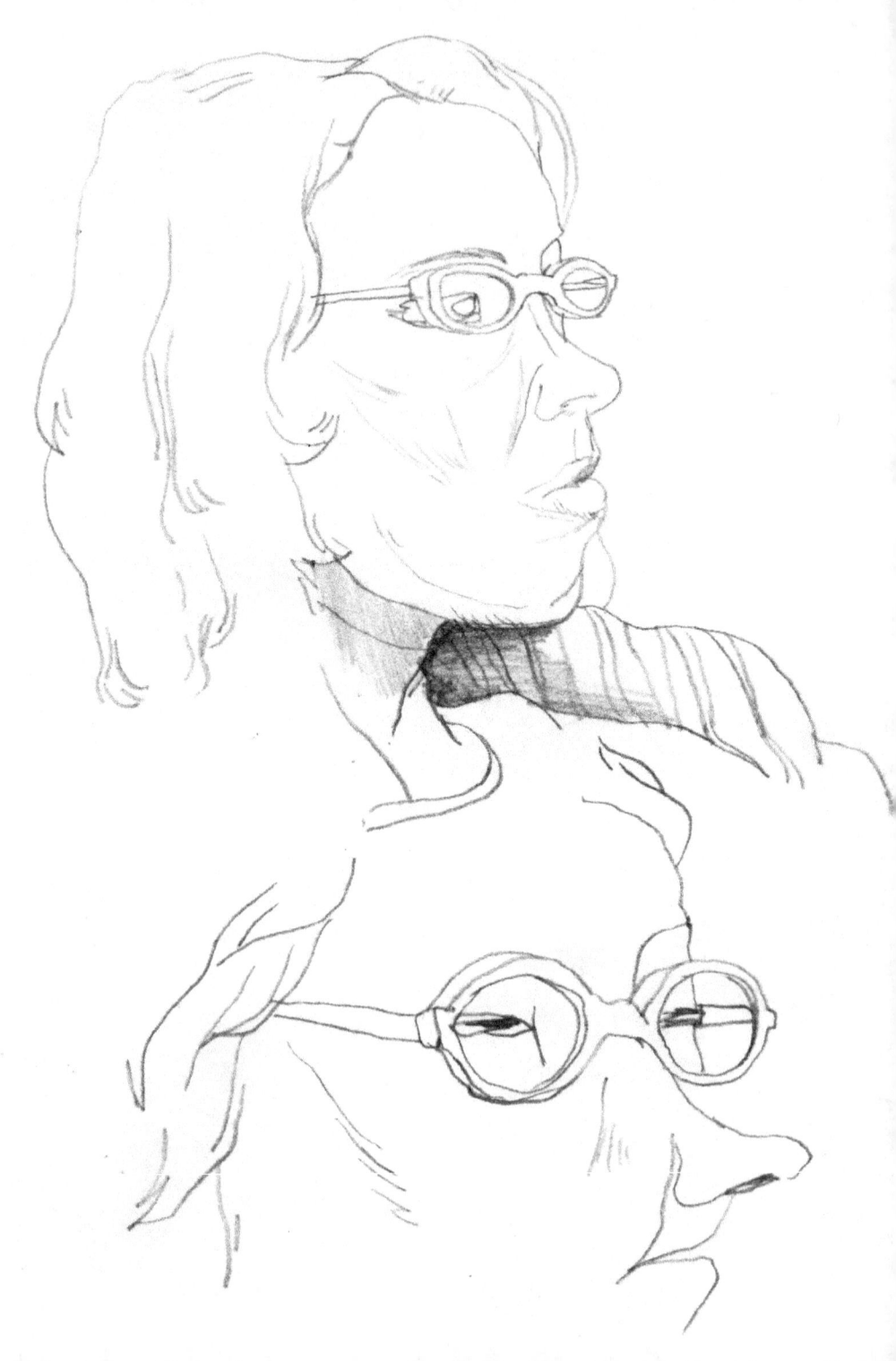

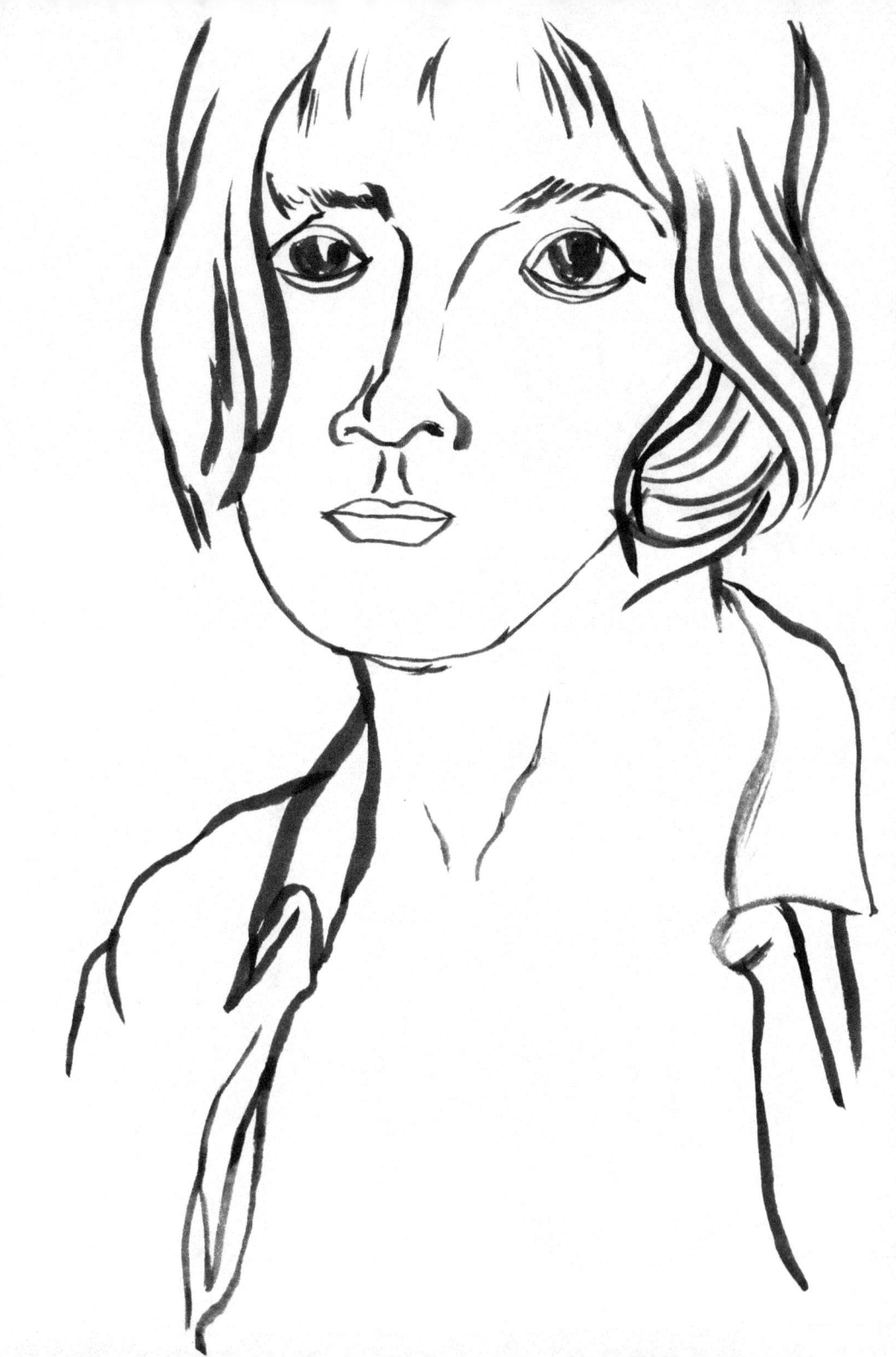

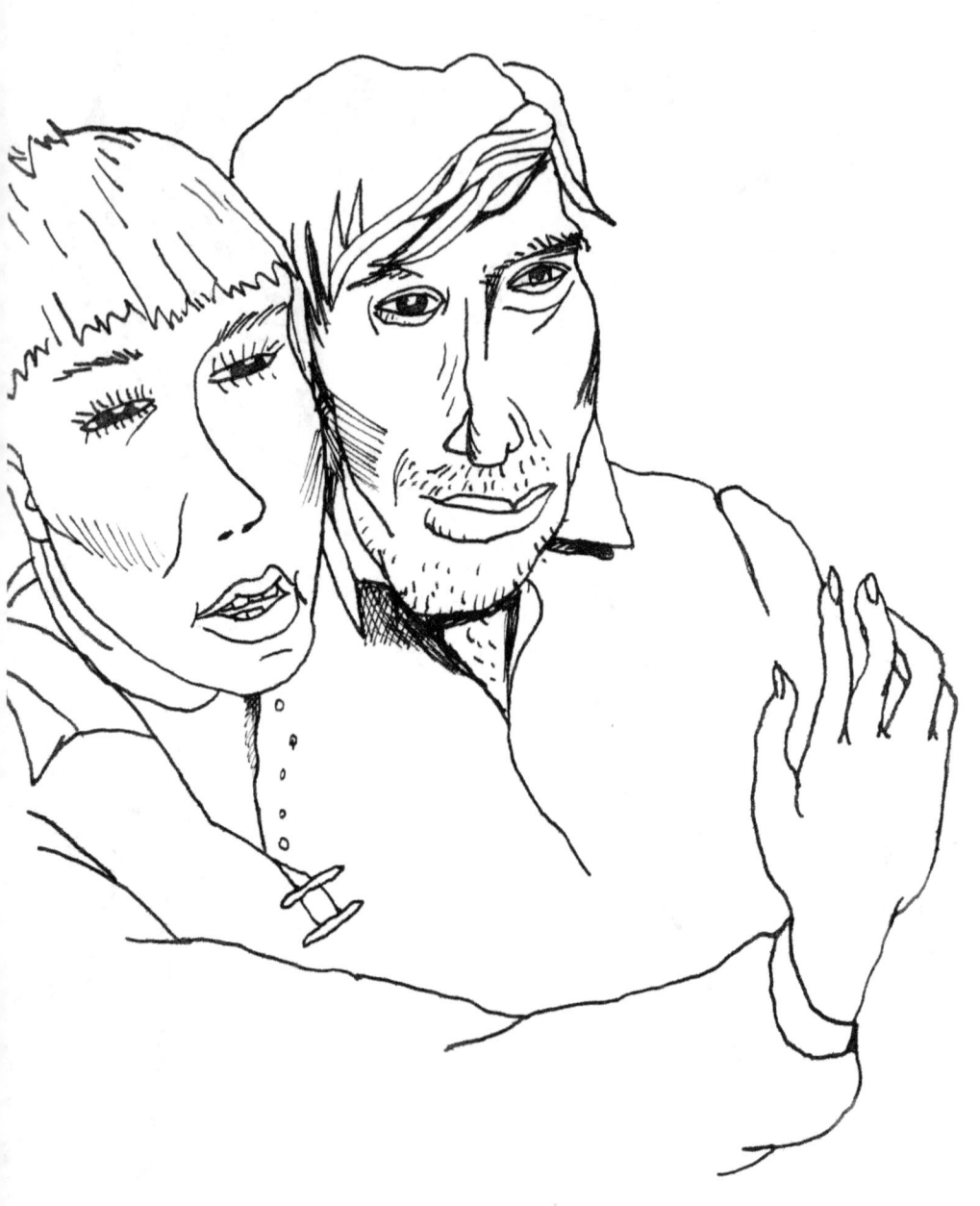

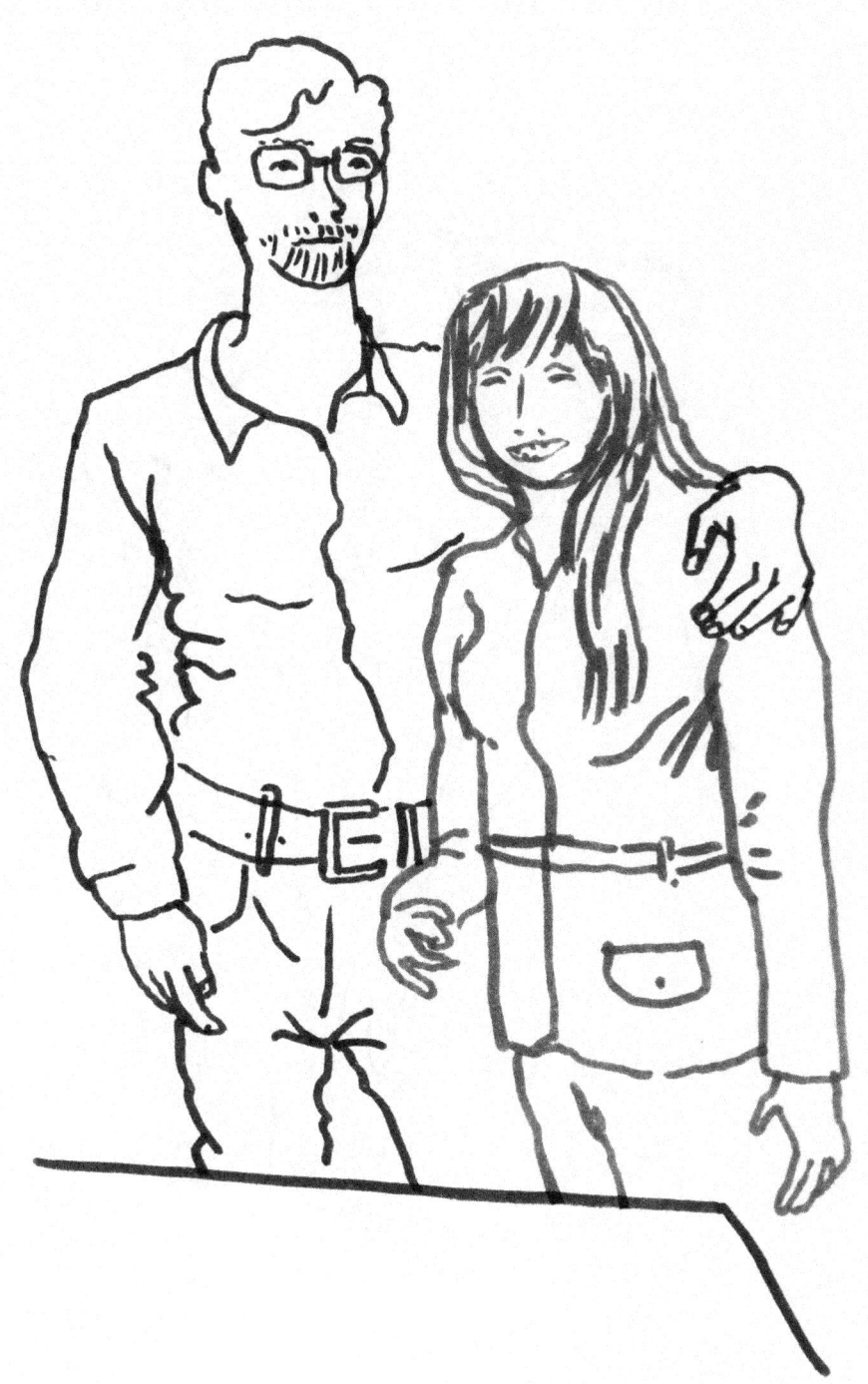

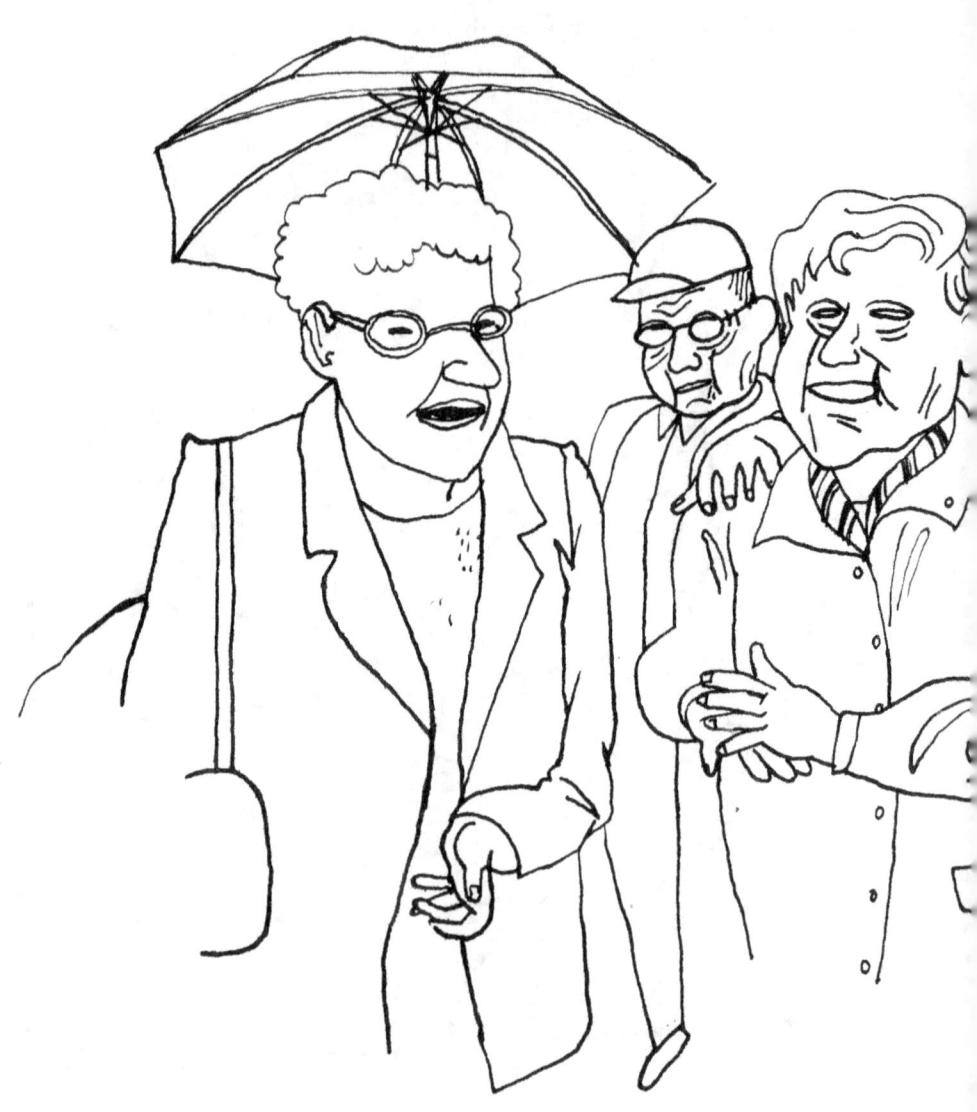

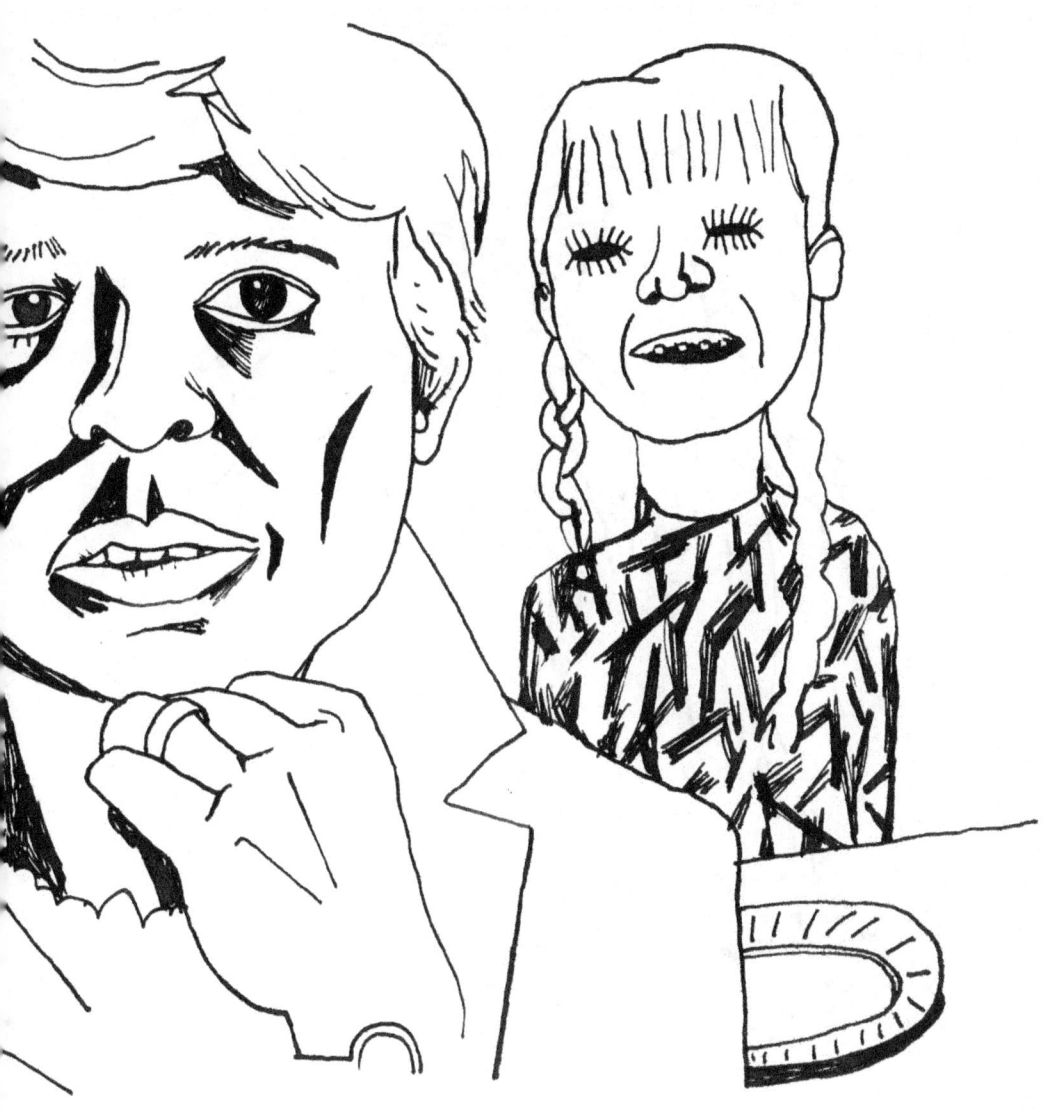

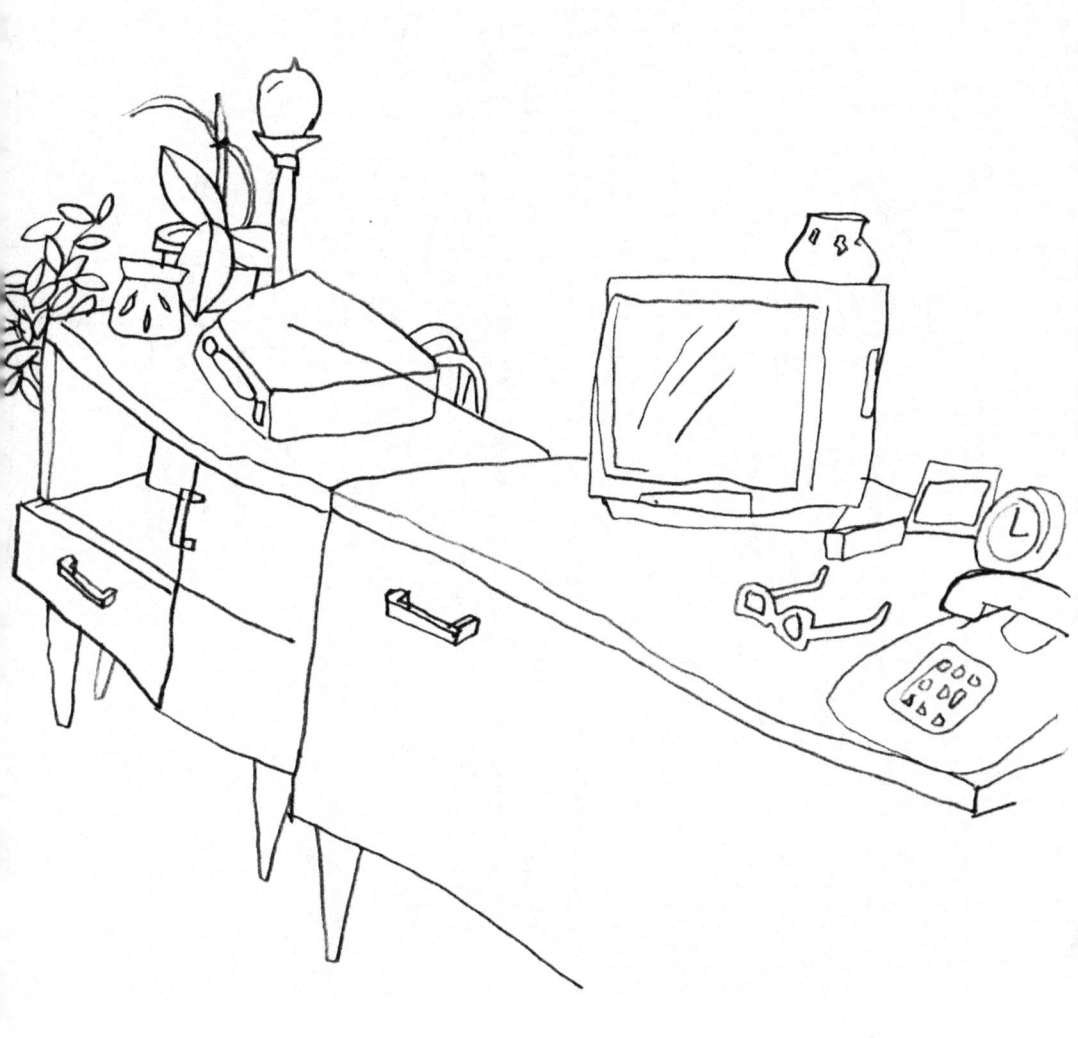

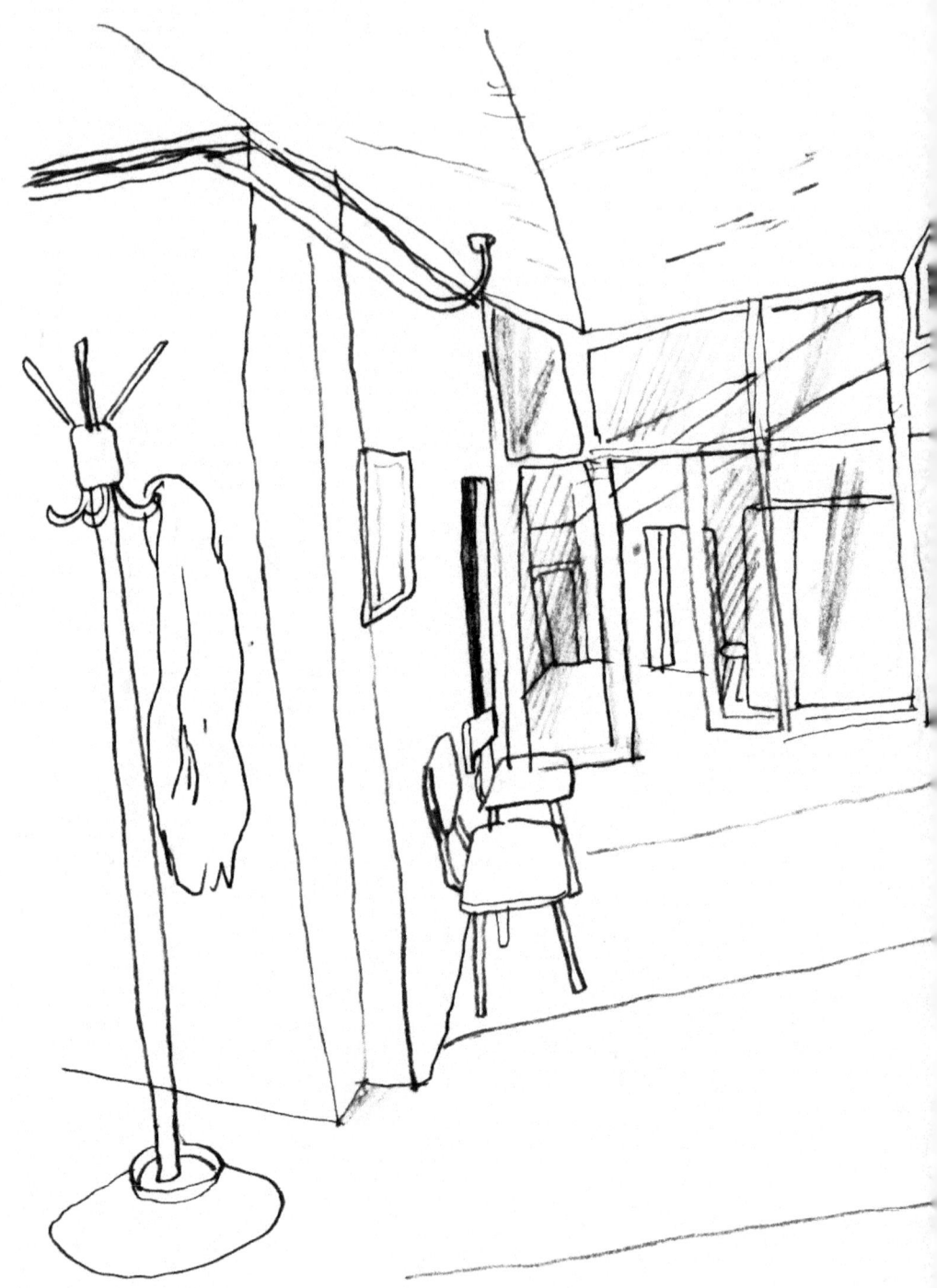

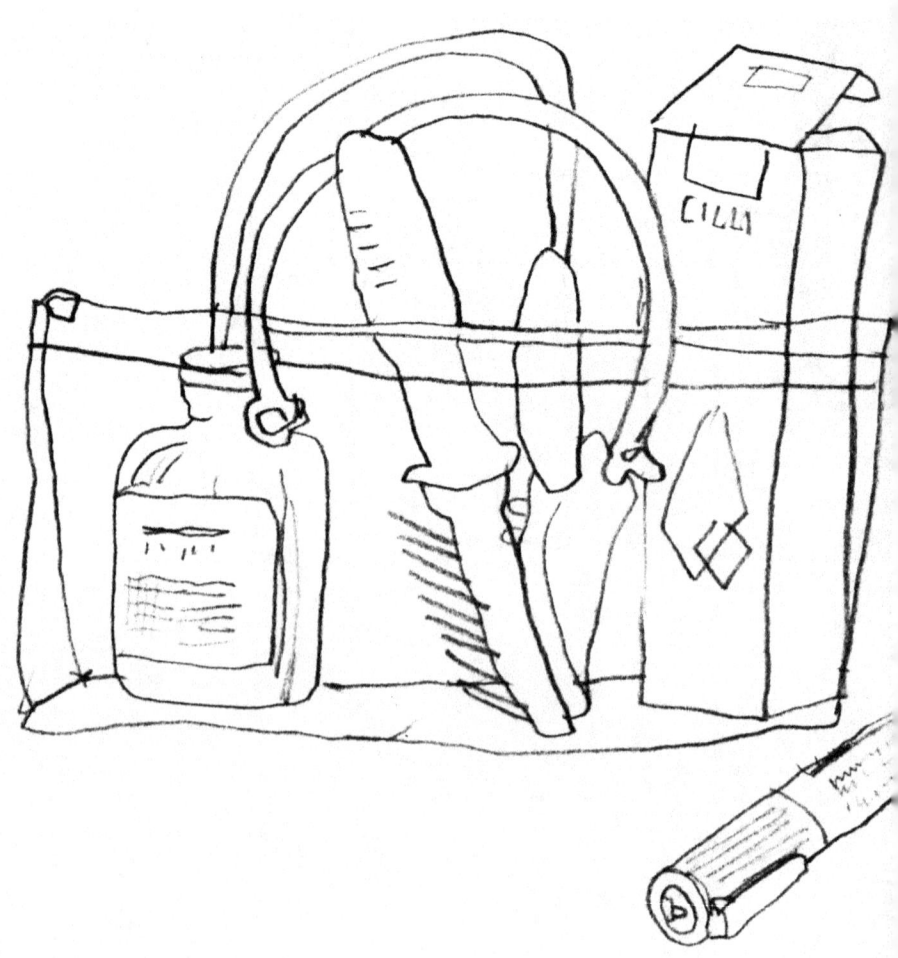

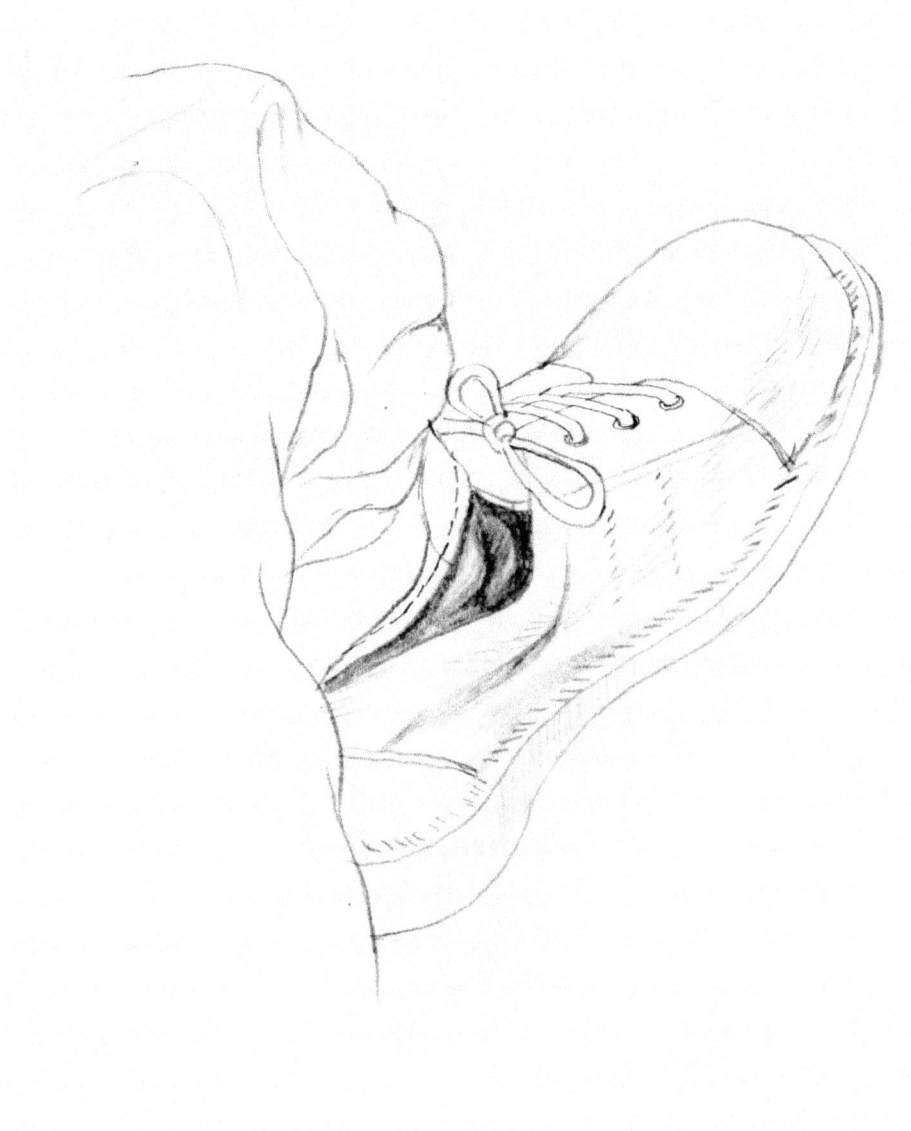

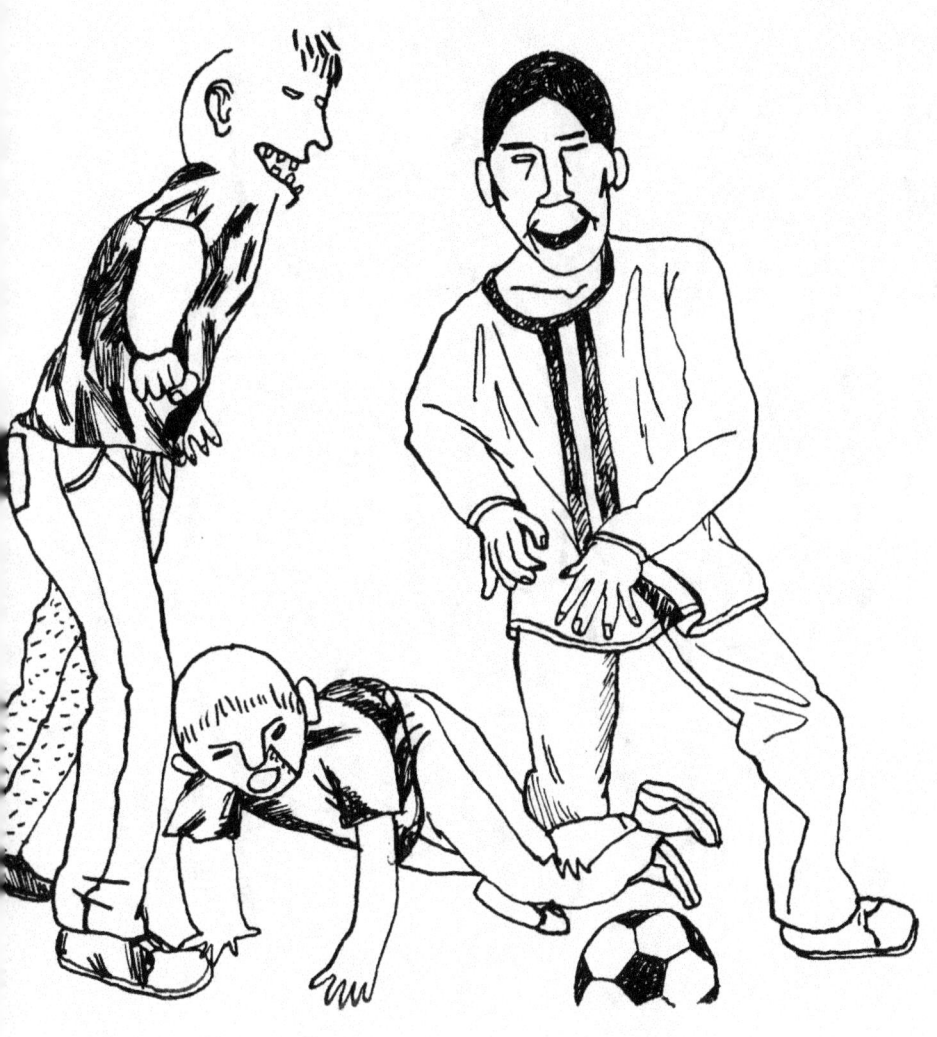

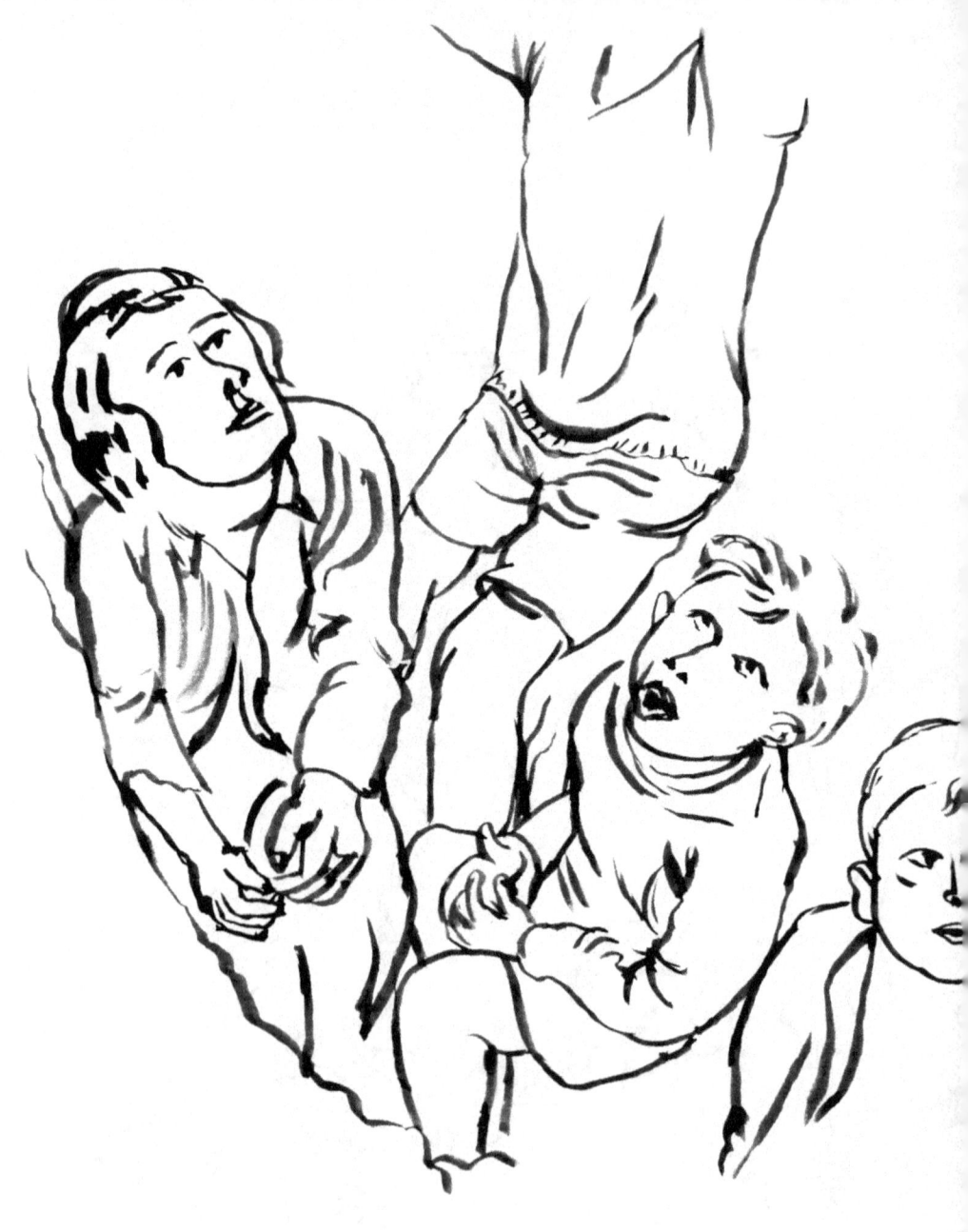

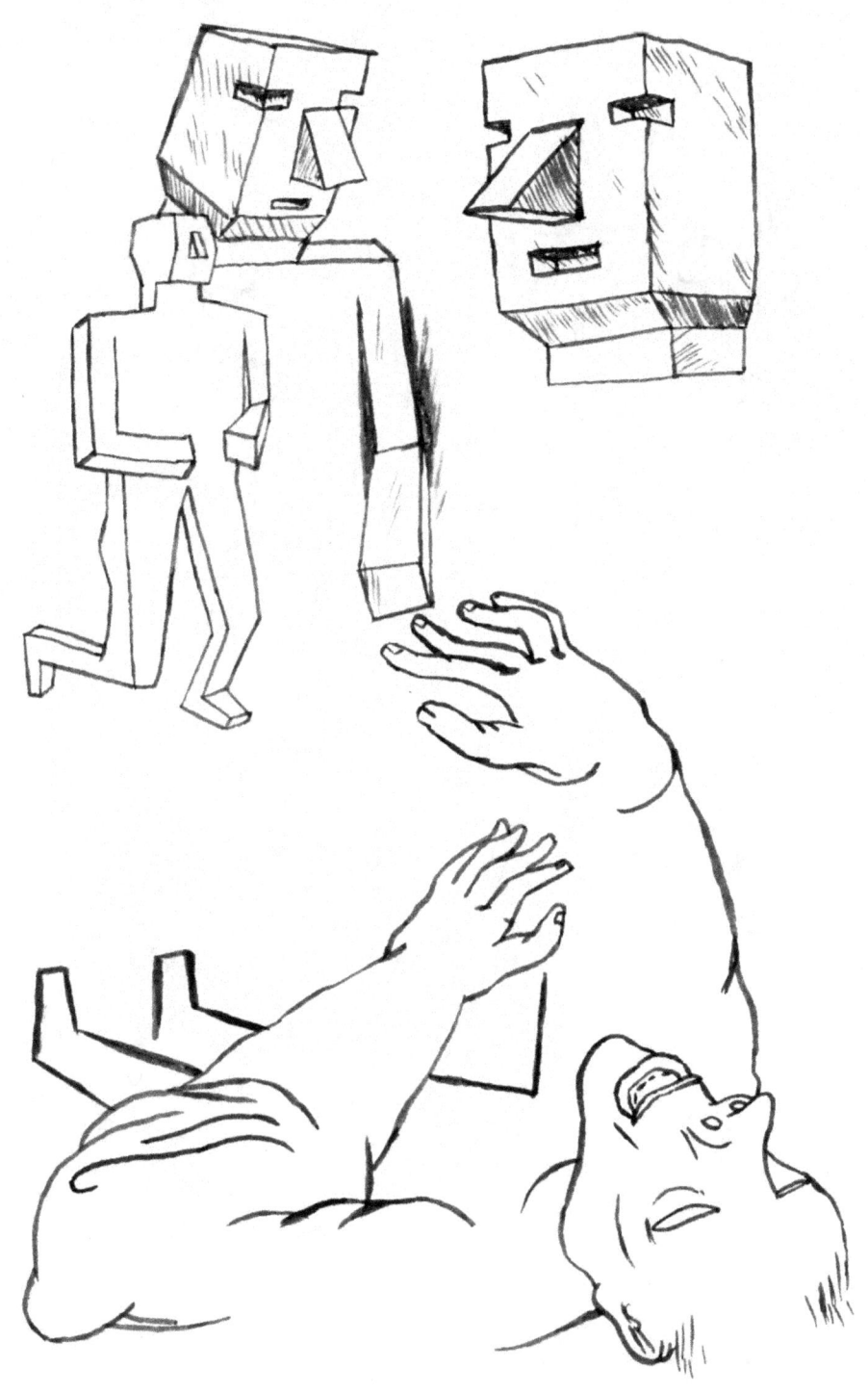

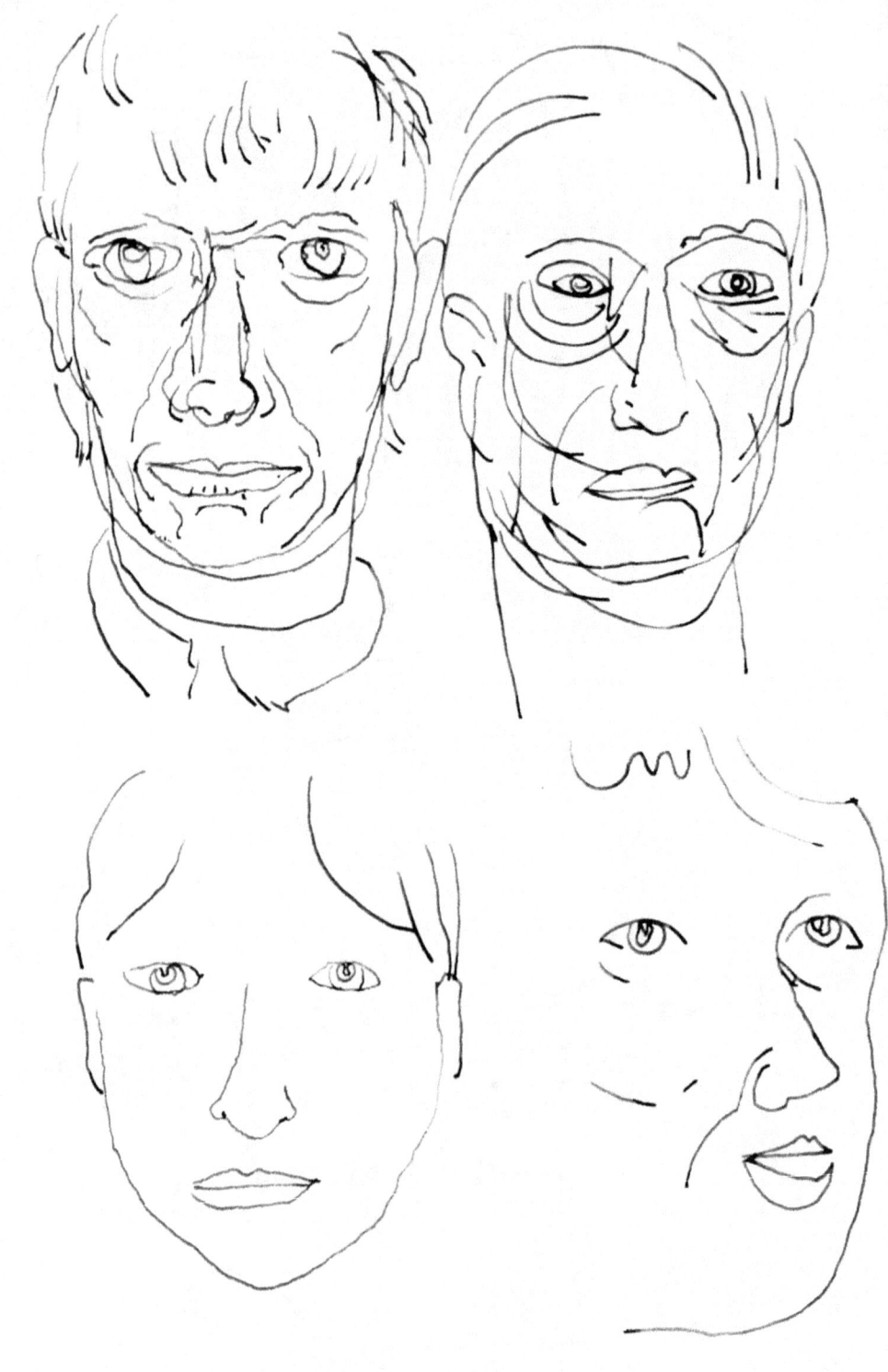

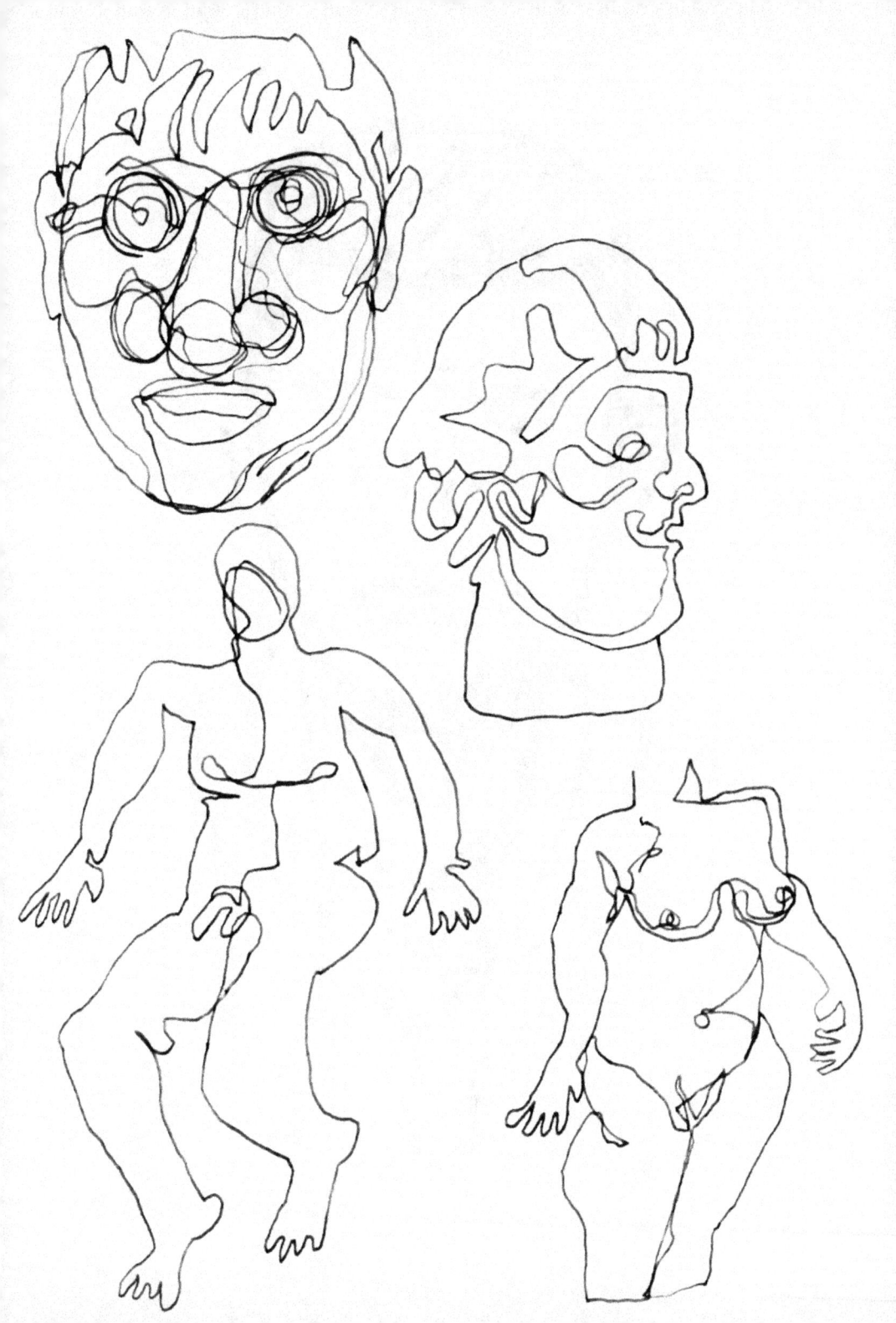

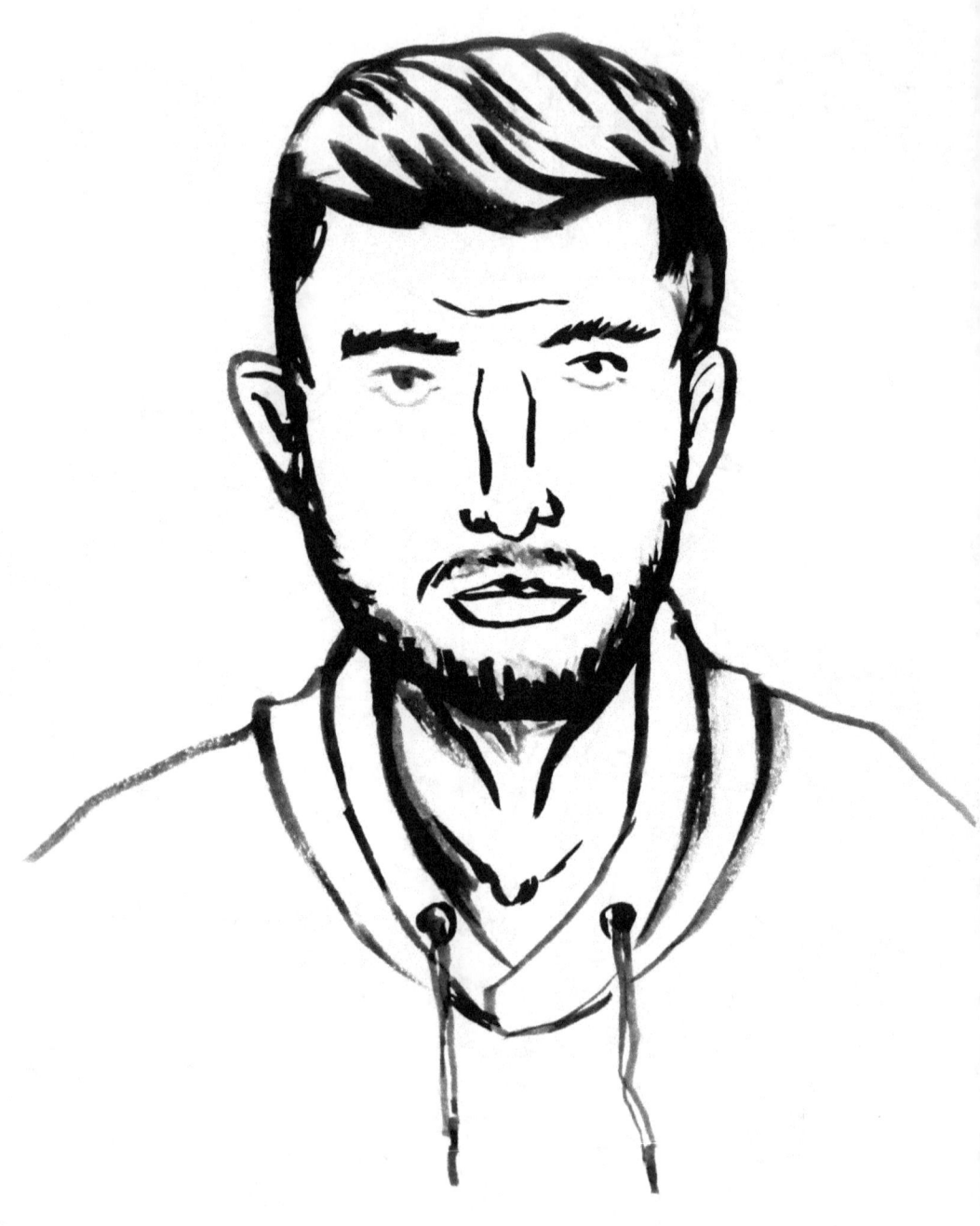

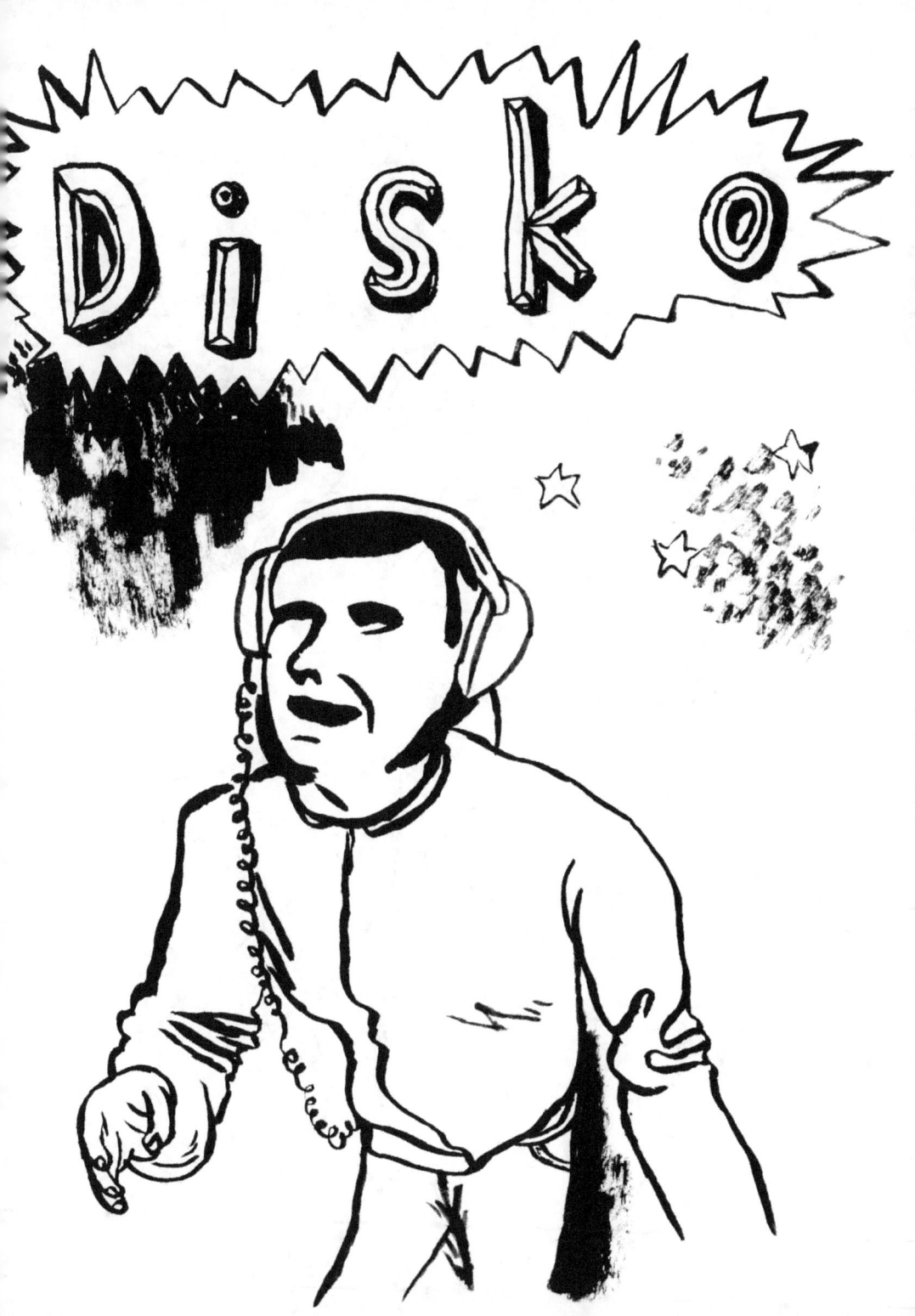

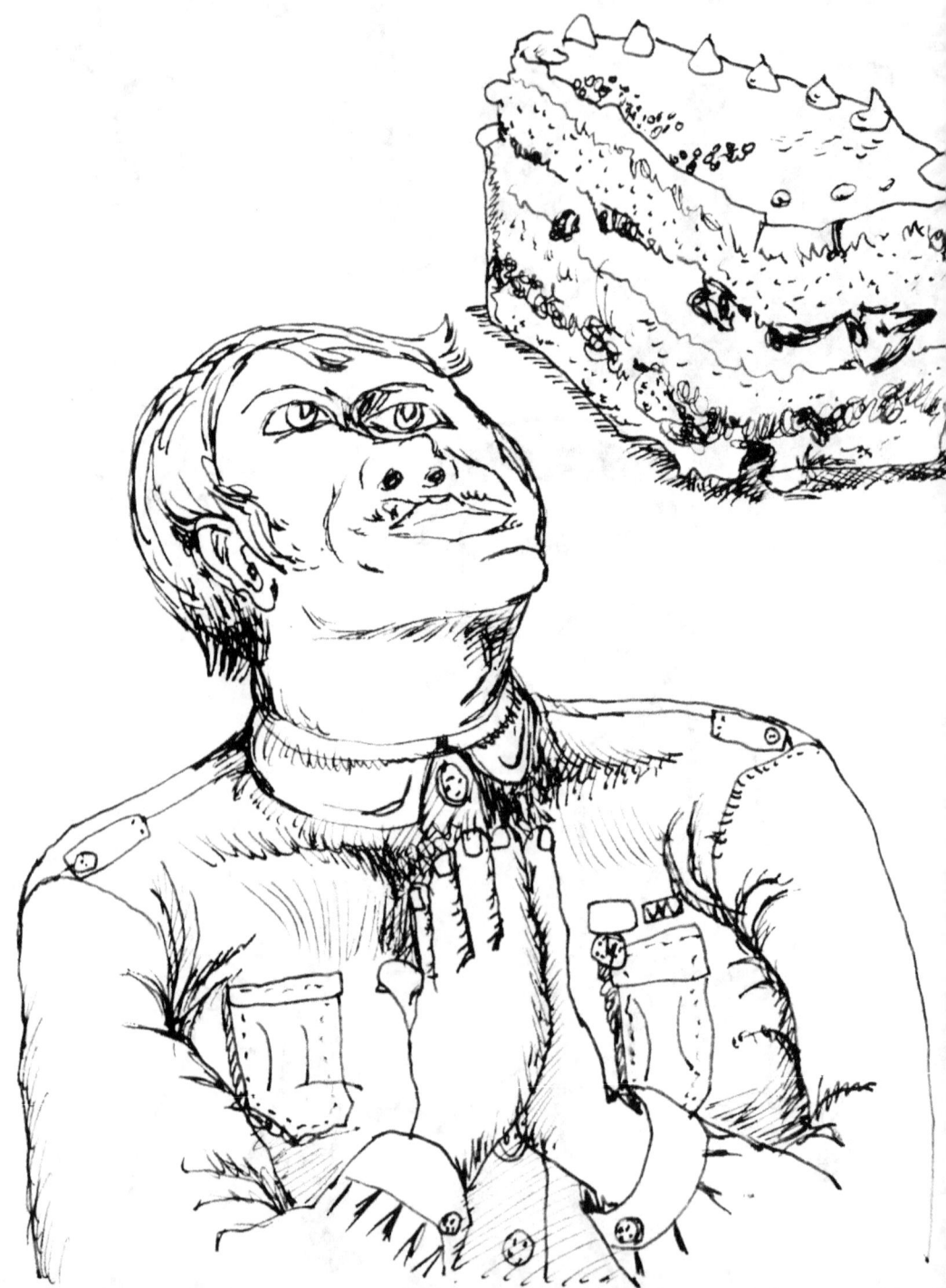

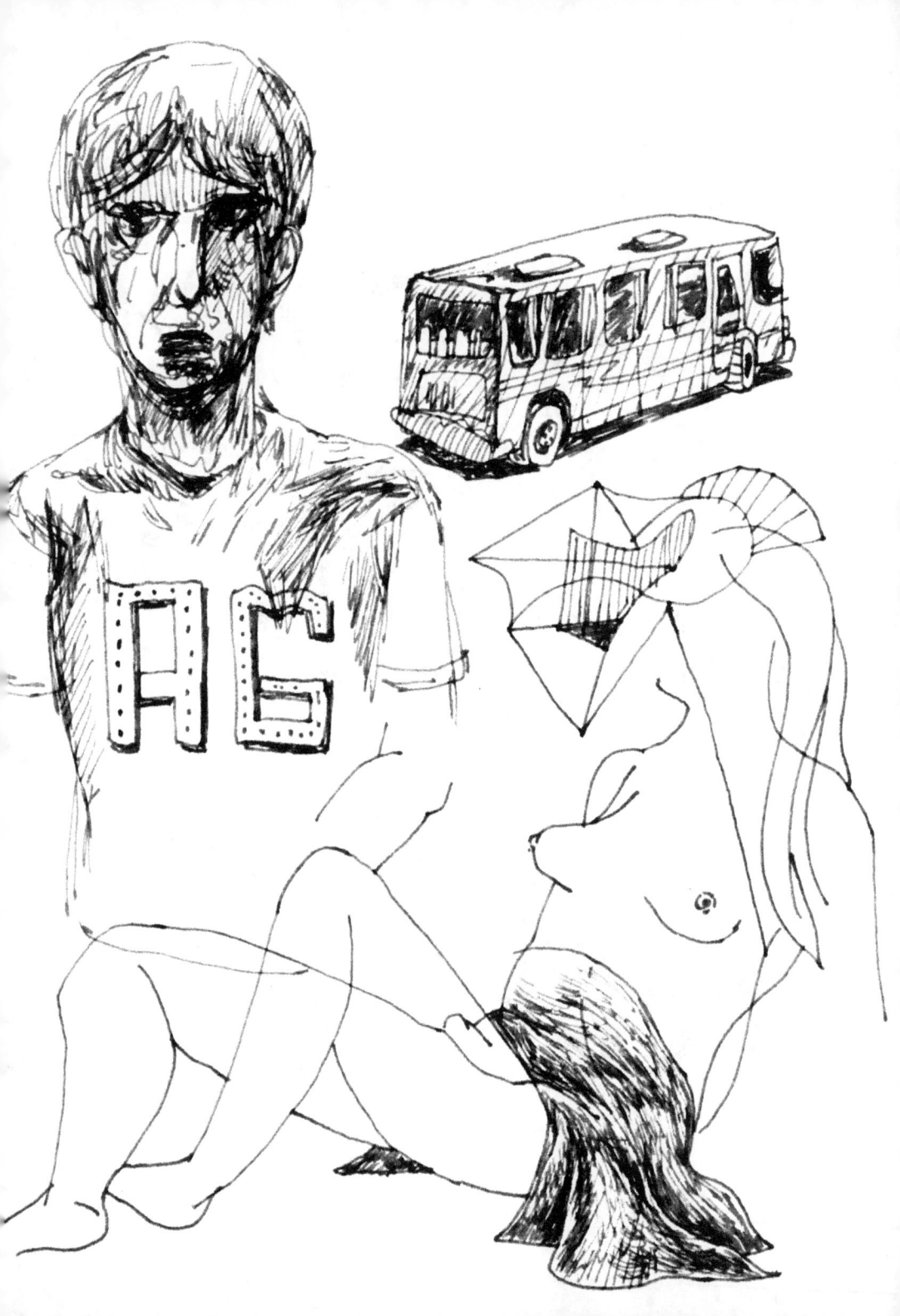

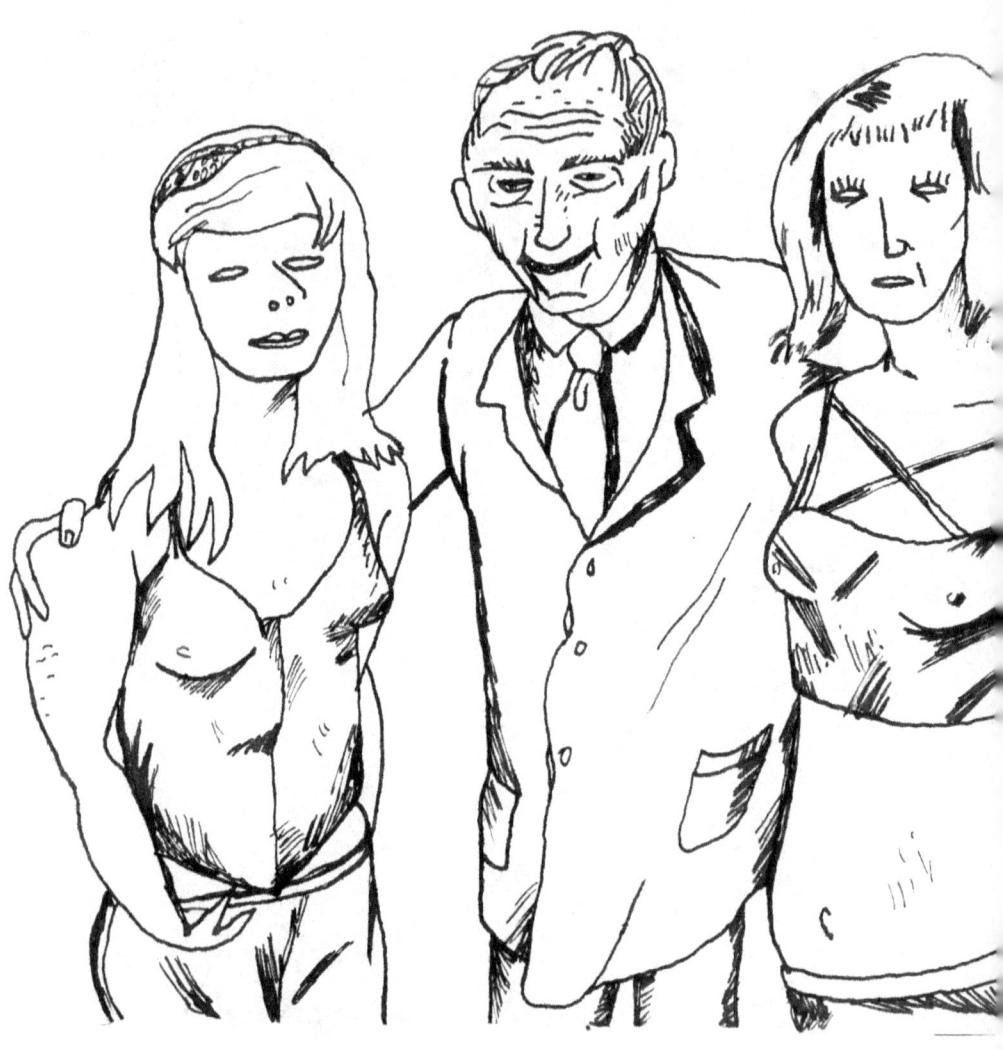

starec

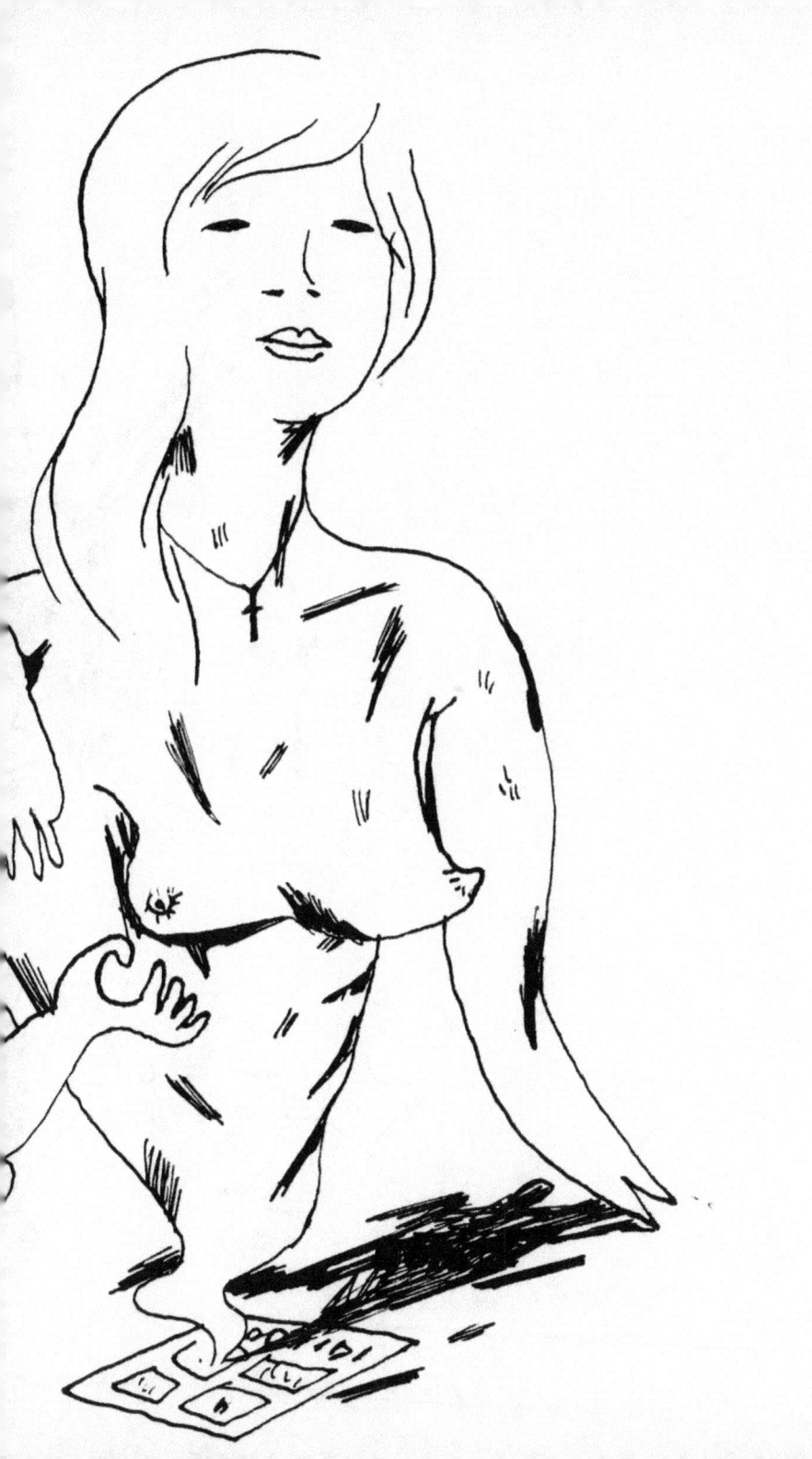

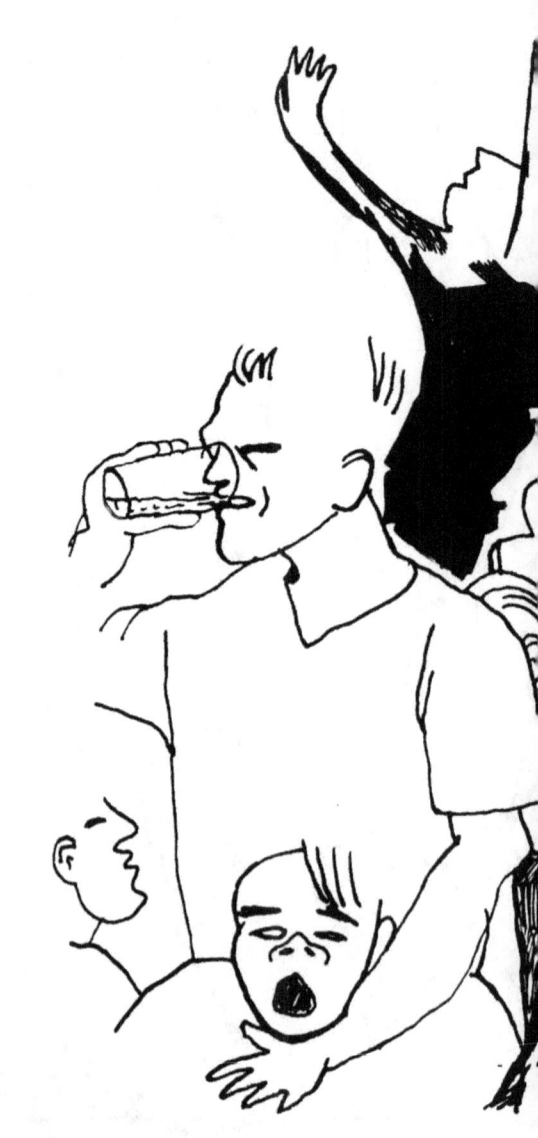

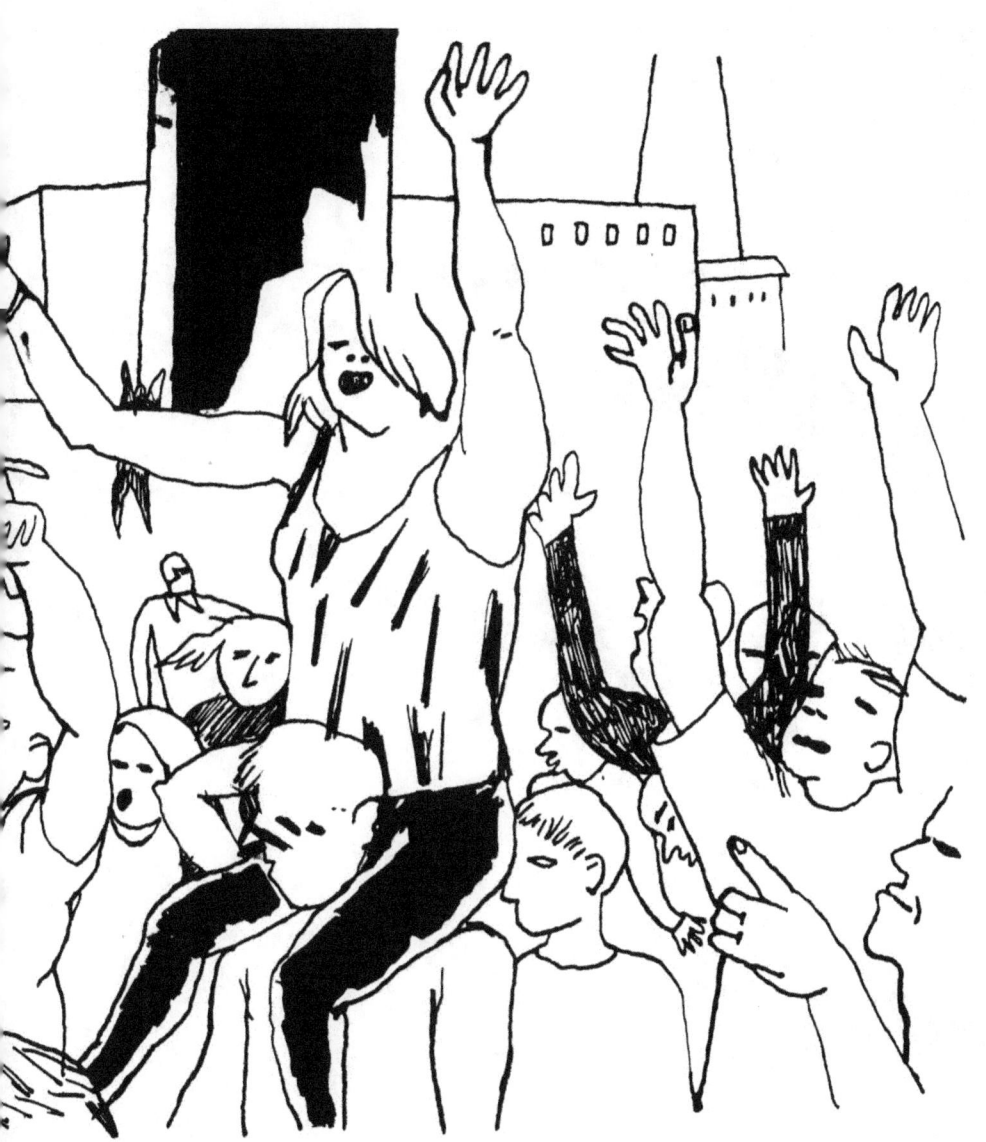

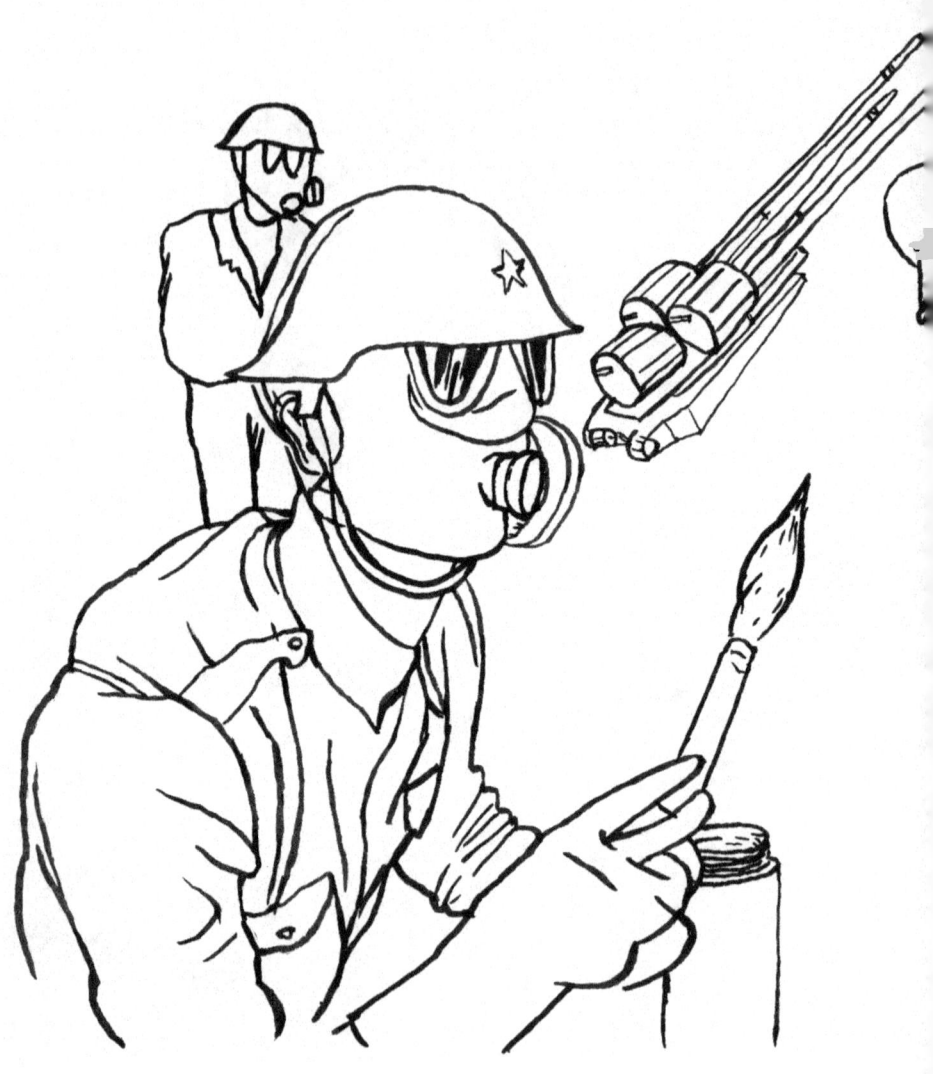

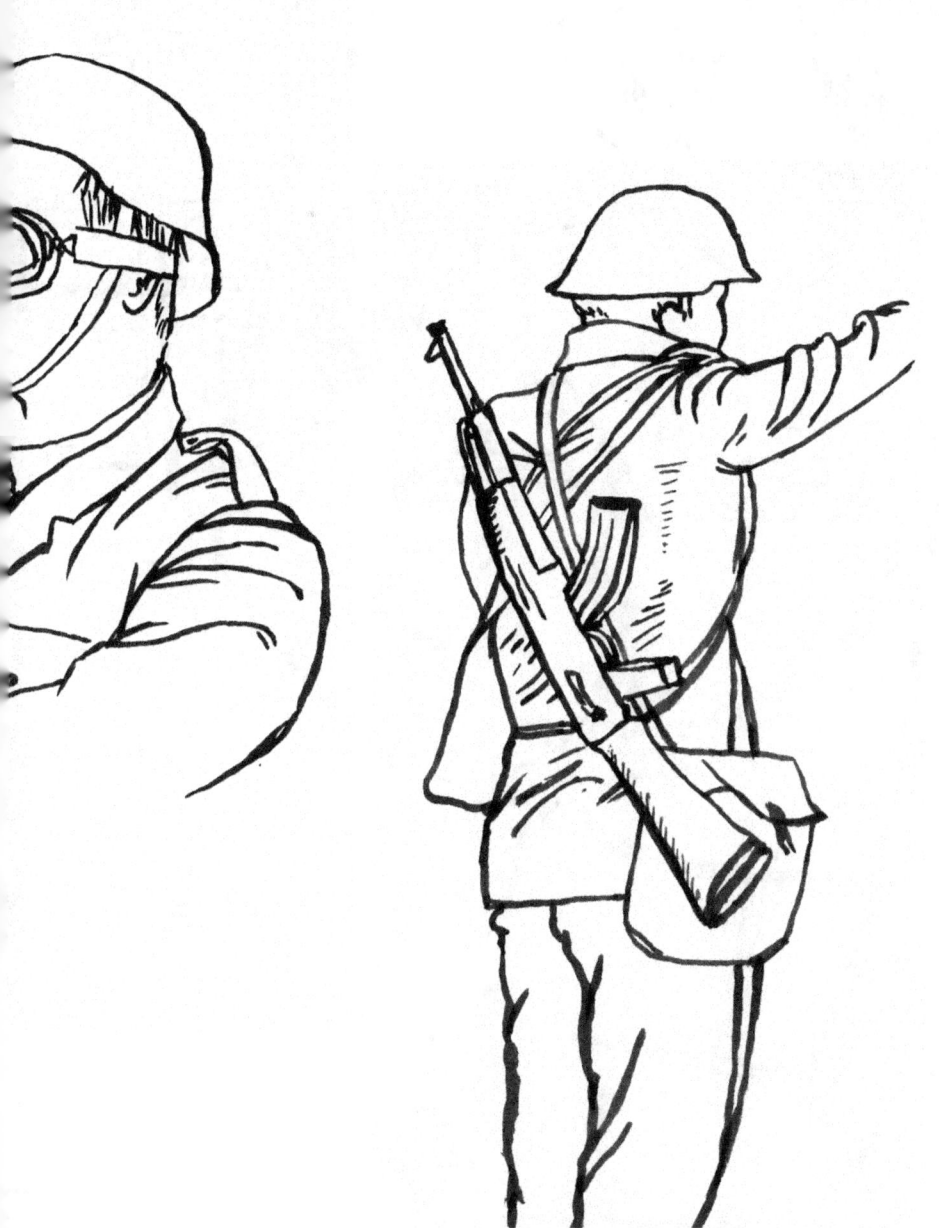

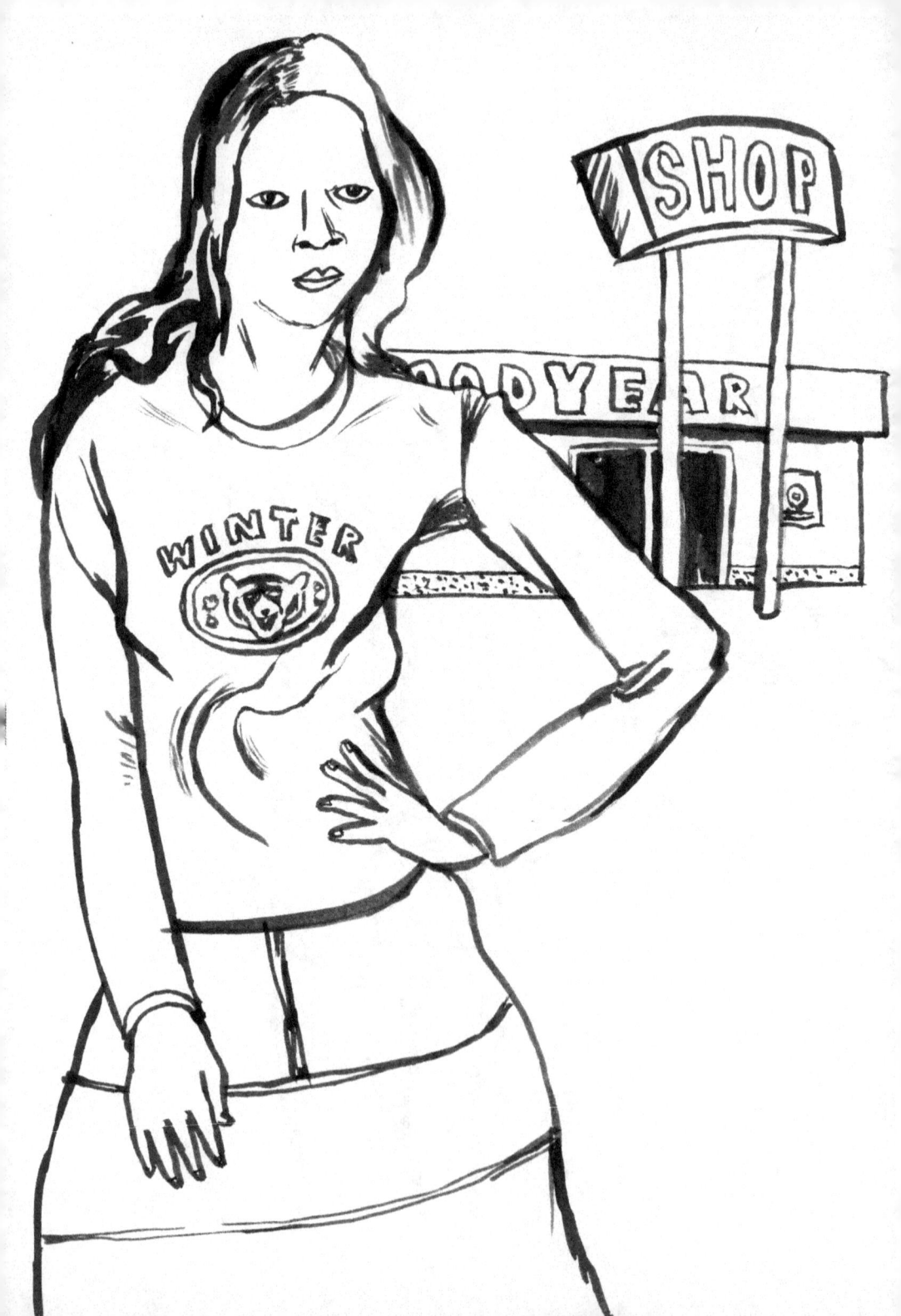

www.ingramcontent.com/pod-product-compliance
Lightning Source LLC
Chambersburg PA
CBHW070433180526
45158CB00017B/1151